WINSOR
The World's Fine

MW00773983

colour mixing guides

oils

a visual reference to mixing oil colour

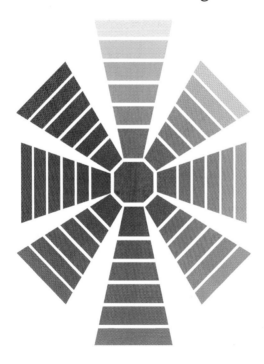

JOHN BARBER

First published in Great Britain in 2007 by
Search Press Limited
Wellwood, North Farm Road
Tunbridge Wells
Kent TN2 3DR

Created and conceived by
Axis Publishing Ltd
8c Accommodation Road
London NW11 8ED
www.axispublishing.co.uk

Creative Director: Siân Keogh
Editorial Director: Anne Yelland
Production Manager: Jo Ryan

ISBN-10: 1-84448-226-X
ISBN-13: 978-1-84448-226-9

Printed in China

Details of your local Winsor & Newton stockist can be found on the
Winsor & Newton web site (www.winsornewton.com)

contents

introduction

Oil colours are made by mixing pigments with drying oils, usually linseed or safflower oil, although artists use many other oils to obtain particular handling qualities. The medium enables artists to produce almost any style or finish from meticulous detail to heavy thick impasto as in the works of Rembrandt (1606–69) and in modern abstract work by artists such as Frank Auerbach (b. 1931). The slow drying qualities of the oil medium enable the colour to be manipulated over long periods, allowing passages of painting to be removed or altered over several days. This does make the handling of freshly painted work difficult and makes the medium unpopular with holiday painters and travellers. For these artists who wish to paint in an opaque manner, acrylics or simply adding white paint (gouache) to water colours are frequently used alternatives.

ABOUT THIS BOOK

This book on colour mixing using oils is intended for both amateur and professional artists, and should prove invaluable both in the studio and when out painting on location. You can use it to match precisely any shade you want to reproduce in your work.

The 25 *Winsor & Newton*™ Oil Colours chosen for the colour wheels give a comprehensive range of 2400 two-colour mixes. The selected colours have been chosen as the most useful for a wide range of oil painting. All the colours can be located in the colour charts and matched by mixing only the two colours shown. This innovative method has the great advantage of enabling you to mix the chosen colour with the absolute minimum number of colours, thereby obtaining the cleanest and brightest tints possible. The need to add a third or even a fourth colour when attempting to match a colour is avoided (generally, the more colours you mix together, the greater the tendency to produce a dull finished colour).

Each pair of colours is shown in five degrees of a mixture and on each colour wheel percentages are marked as a guide to the proportion of each colour that was used to produce the mix. Start

with one colour at full strength then add the second colour gradually until the desired colour on the wheel is matched. Note that these mixes were made using *Winsor & Newton* Artists' Oil Colours; colours by other manufacturers will give varying results.

ABOUT ARTISTS' COLOURS

Winsor & Newton Artists' Oil Colour combines the strongest tinting power with consistent blending quality throughout the range, allowing artists complete flexibility of working method. Thinning the colour with turpentine or mineral spirit will produce a thin, transparent layer of colour to allow you to establish the composition. Take care not to over-thin the paint as this will cause the oil to lose its binding qualities and the colour will become too liquid.

CHOICE OF COLOURS

It may seem surprising that several lovely subtle colours are not included. However, by looking at the appropriate colour wheels, you will find very close matches to most shades. Experienced painters may find that some of their favourite colours are missing from the charts, but may be surprised by how many can be replicated extremely closely by other two-colour combinations.

MIXING COLOUR

Tube colours that are already mixed with oil need only a little mineral spirit, turpentine or odourless solvent to make them workable. If you like to blend colours smoothly and lose your brush marks and you are painting in layers, add a little oil as your painting progresses. Linseed oil is most commonly used, but poppy and walnut oils have their own subtle qualities.

When mixing colours, start with the lighter colour and gradually add the darker colour to it. In this way, you will avoid mixing too much colour. If you start with too much of the darker or stronger colour, you will need a great deal of the lighter colour to create the tint you are trying to achieve.

SUGGESTED PALETTES

It is a good idea for beginners to start with a very restricted palette of six colours and use the charts relating to these six colours to develop their colour skills and discover their preferences. They can then augment their palette as they gain experience. A good minimum palette for a beginner is:

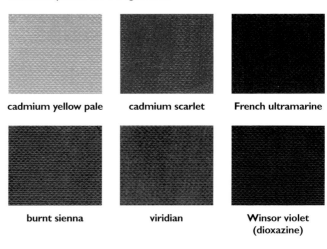

cadmium yellow pale cadmium scarlet French ultramarine

burnt sienna viridian **Winsor violet (dioxazine)**

It is interesting to look at the colour palettes of the some of the great painters of the past.

James MacNeill Whistler in his water colours used Prussian blue, raw umber, raw sienna, yellow ochre, vermilion, burnt sienna, Venetian red and black.

Mixing any two of these would give very subdued secondaries. The predominance of the earth colours in this palette demonstrates how he obtained his subtle colour schemes.

Claude Monet, another great colourist, in his atmospheric London paintings said that he used (in oil) only five colours. These were cadmium yellow, vermilion, rose madder deep, cobalt blue and emerald green.

The palette of **William Russell Flint** was cobalt blue, ultramarine, cerulean blue, light red, yellow ochre, Indian yellow, burnt sienna and rose madder. Even this small group would not all have been used in any one picture.

Rowland Hilder had 27 colours in his paintbox but rarely used more than eight in any one painting. Many of his neutral greys were made with lamp black and a touch of burnt sienna or Payne's gray and a touch of ultramarine.

One of the most popular supports for works in oil paints is canvas. Canvases are available pre-stretched in various sizes and different textures from smooth to extremely coarse grained.

how to use this book

Each double page spread features a named colour from the range below. In practice most artists will use far fewer colours than this. To each base colour are added named colour mixers in different percentage strengths which will help you to achieve the precise shade you want. The colours are organized into colour groups: yellows, reds, purples, blues, greens and browns, with mix colours chosen as being of most use to artists working in oils. The hue variations information at the foot of each double-page spread shows you where to look if your mix is not quite what you want.

THE OIL COLOUR PALETTE

These are the most versatile and popular Artists' Oil Colours, available in art stores and via the Internet.

Colours included in many pre-selected painting boxes are also chosen from this range.

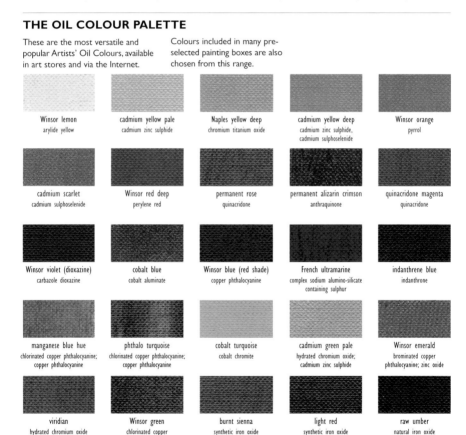

Winsor lemon
arylide yellow

cadmium yellow pale
cadmium zinc sulphide

Naples yellow deep
chromium titanium oxide

cadmium yellow deep
cadmium zinc sulphide,
cadmium sulphoselenide

Winsor orange
pyrrol

cadmium scarlet
cadmium sulphoselenide

Winsor red deep
perylene red

permanent rose
quinacridone

permanent alizarin crimson
anthraquinone

quinacridone magenta
quinacridone

Winsor violet (dioxazine)
carbazole dioxazine

cobalt blue
cobalt aluminate

Winsor blue (red shade)
copper phthalocyanine

French ultramarine
complex sodium alumino-silicate
containing sulphur

indanthrene blue
indanthrone

manganese blue hue
chlorinated copper phthalocyanine;
copper phthalocyanine

phthalo turquoise
chlorinated copper phthalocyanine;
copper phthalocyanine

cobalt turquoise
cobalt chromite

cadmium green pale
hydrated chromium oxide;
cadmium zinc sulphide

Winsor emerald
brominated copper
phthalocyanine; zinc oxide

viridian
hydrated chromium oxide

Winsor green
chlorinated copper
phthalocyanine

burnt sienna
synthetic iron oxide

light red
synthetic iron oxide

raw umber
natural iron oxide

Use the at-a-glance percentage mixes to see what will result from a mix of two colours in a range of five different percentage strengths. The colour at the centre of the "wheel" is 100 per cent of the colour named on the spread; the ends of the "spokes" are 100 per cent strength mixer colour.

section colour colours are grouped into primary or secondary colours; related colours appear one after the other.

percentage mix the percentages of each colour are indicated, from full strength main shade at the centre to full-strength second colour at the edge.

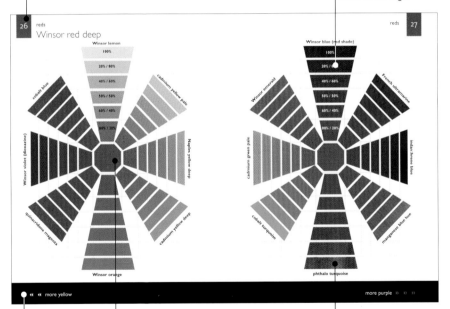

hue variations if your mix is not right, going back in the selector will give mixes containing more of a different colour.

base colour one of the 25 colours shown opposite appears on every spread, with mixes of percentages of further colours.

mix colour full-strength swatches of the mixer colour appear at the ends of the spokes of the colour wheel.

supports and brushes

For mixing oil colours you need a flat smooth surface that will not absorb the oil. The traditional palette in wood or plastic, including a thumb hole, is necessary for portrait and outdoor work, but in the studio many artists use a piece of glass, plastic or glazed ceramic appropriate to the size of their paintings. The ultimate in economy is to use a glossy magazine and tear off each page when it is full.

Squeeze out each colour onto your palette as a long line of colour rather than as a large round blob. You will then be able to take colour from the end of the line without staining the rest of the colour: any colour left will be clean for further use. Place each colour along the far edge of your palette so that you can see all the colours clearly. The order of the colours on the palette is a matter of personal choice, but do not change it too often as this will slow down the work. One idea is to start with cool colours, the blues and violets, on the left, moving through the yellows to the ochres and earth colours with reds on the right. Place white and black on the extreme right.

A traditional paintbox containing 12 or 24 tubes of colour, together with palette, brushes and thinning oils ensures everything is to hand when you are ready to paint.

SUPPORTS FOR OIL PAINTING

Wood panels, canvas, card-backed canvas, hardboard, MDF (medium-density fibreboard), card and paper (properly primed to prevent the paint from sinking) are all suitable grounds for oil painting.

The difficulty and expense of joining wood to make large panels and their tendency to crack led to the use of canvas and other textiles which were lighter in weight and allowed much larger pictures to be made and hung. Pictures in the 19th century French Salons were sometimes 10 metres long. The woven texture of canvas allows every variation from smooth grain to extremely coarse to be used and gives the opportunity to elaborate yet more ways of painting with oils in the future.

BRUSHES

Hog-hair brushes are the most popular brushes for oil painting; they are the most effective when handling colour from tubes diluted, if at all, with a little turpentine. Paint dissolved with other liquids or resins requires softer fibres or hairs to enable you to obtain softer blending. Of these sable is still the best, but by a narrower margin than in the past. The various synthetic fibres offer good quality at a fraction of the cost of sable.

When you begin to use the opaque method of painting by adding white to alter the tone of the colours, use a palette knife to do the mixing so that your clean brush is ready to pick up just the amount of colour needed.

Many painters who favour a broader approach use palette knives and other painting tools either to add dramatic touches or to paint the whole picture.

Choose several hog-hair brushes in different sizes and shapes for your oil painting. This allows you to create works of art, whatever your style. Palette knives are useful additions.

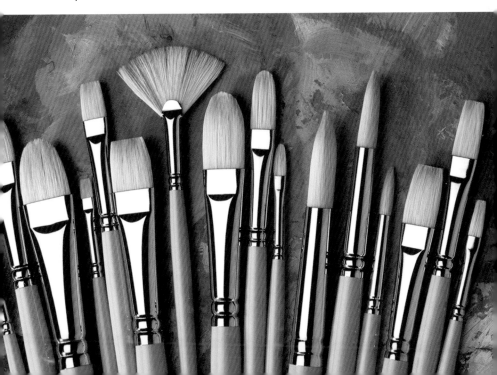

the
colour mixes

The following pages feature 25 main colours from the *Winsor & Newton* Artists' Oil Colour range, the most popular range with amateur and professional artists. The mixes demonstrate that artists need very few colours to create an enormous range of bright, vibrant colours in oil colour. Use these mixes as guides to help you to achieve the exact shade you want, whatever your subject.

Winsor lemon

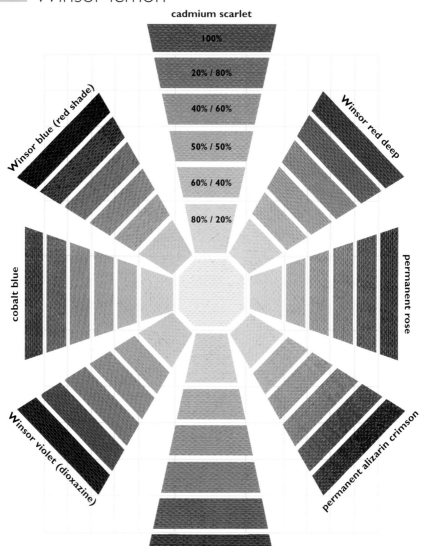

cadmium scarlet

100%

20% / 80%

40% / 60%

50% / 50%

60% / 40%

80% / 20%

Winsor blue (red shade)

Winsor red deep

cobalt blue

permanent rose

Winsor violet (dioxazine)

permanent alizarin crimson

quinacridone magenta

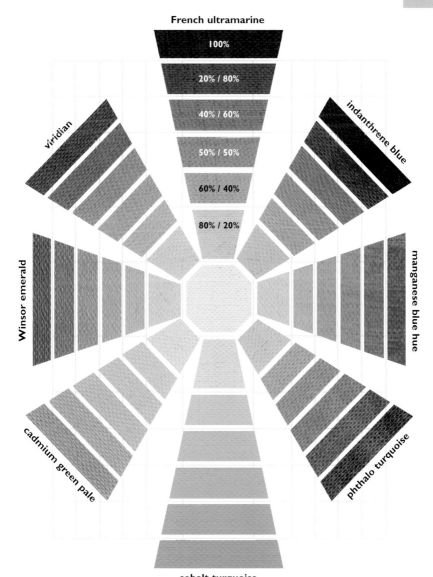

French ultramarine

100%

20% / 80%

40% / 60%

50% / 50%

60% / 40%

80% / 20%

indanthrene blue

Viridian

Winsor emerald

manganese blue hue

cadmium green pale

phthalo turquoise

cobalt turquoise

cadmium yellow pale

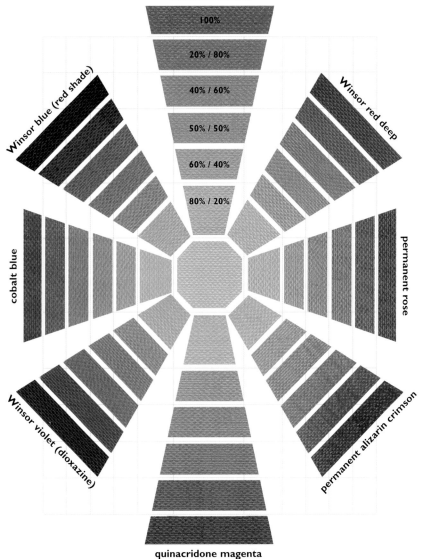

cadmium scarlet

100%

20% / 80%

40% / 60%

50% / 50%

60% / 40%

80% / 20%

Winsor blue (red shade)

Winsor red deep

cobalt blue

permanent rose

Winsor violet (dioxazine)

permanent alizarin crimson

quinacridone magenta

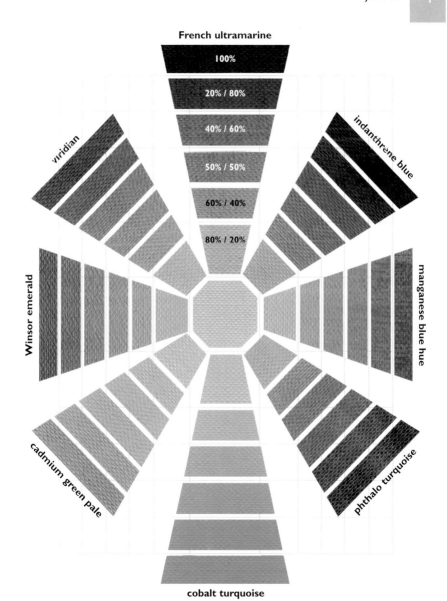

French ultramarine

100%

20% / 80%

40% / 60%

50% / 50%

60% / 40%

80% / 20%

viridian

indanthrene blue

Winsor emerald

manganese blue hue

cadmium green pale

phthalo turquoise

cobalt turquoise

Naples yellow deep

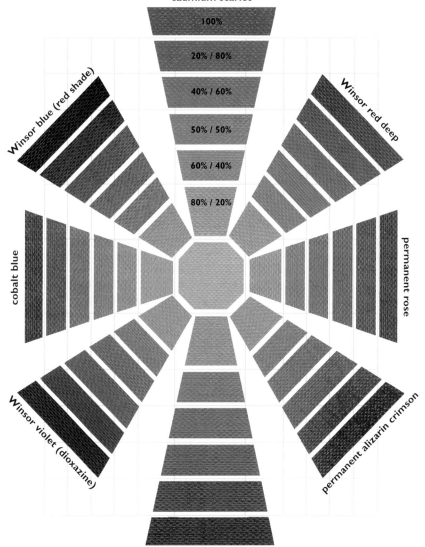

cadmium scarlet

100%

20% / 80%

40% / 60%

50% / 50%

60% / 40%

80% / 20%

Winsor blue (red shade)

Winsor red deep

cobalt blue

permanent rose

Winsor violet (dioxazine)

permanent alizarin crimson

quinacridone magenta

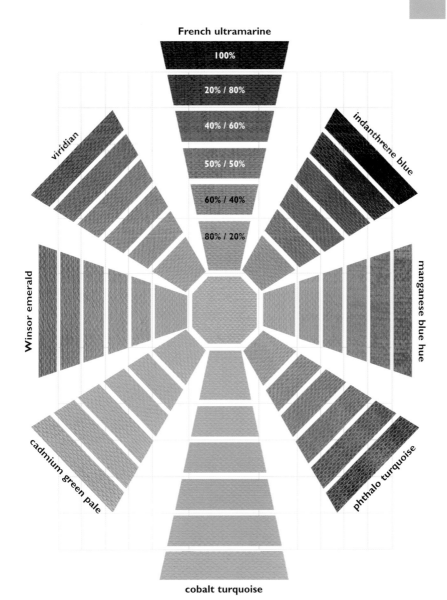

French ultramarine

100%

20% / 80%

40% / 60%

50% / 50%

60% / 40%

80% / 20%

viridian

indanthrene blue

Winsor emerald

manganese blue hue

cadmium green pale

phthalo turquoise

cobalt turquoise

cadmium yellow deep

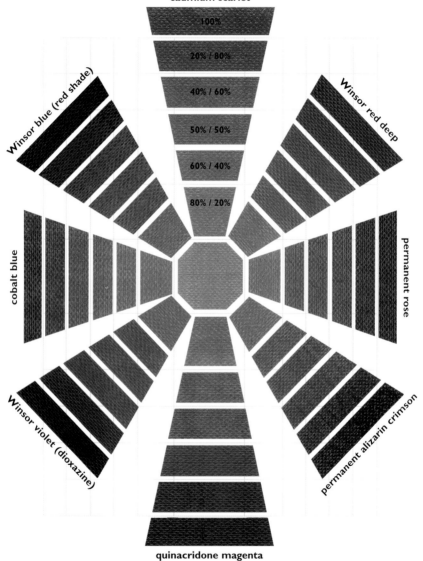

cadmium scarlet

100%

20% / 80%

40% / 60%

50% / 50%

60% / 40%

80% / 20%

Winsor blue (red shade)

Winsor red deep

cobalt blue

permanent rose

Winsor violet (dioxazine)

permanent alizarin crimson

quinacridone magenta

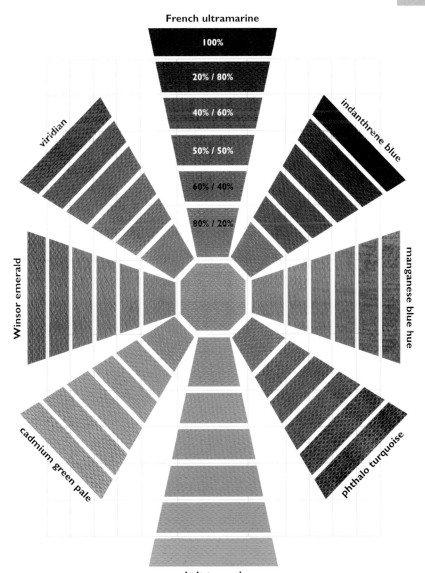

French ultramarine

100%

20% / 80%

40% / 60%

50% / 50%

60% / 40%

80% / 20%

indanthrene blue

viridian

Winsor emerald

manganese blue hue

cadmium green pale

phthalo turquoise

cobalt turquoise

Winsor orange

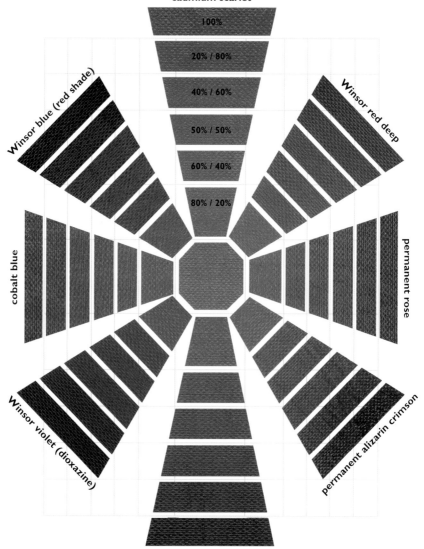

cadmium scarlet

100%

20% / 80%

40% / 60%

50% / 50%

60% / 40%

80% / 20%

Winsor blue (red shade)

Winsor red deep

cobalt blue

permanent rose

Winsor violet (dioxazine)

permanent alizarin crimson

quinacridone magenta

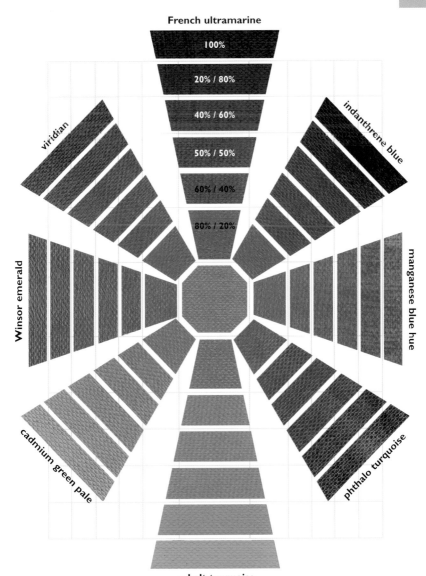

French ultramarine

100%

20% / 80%

40% / 60%

50% / 50%

60% / 40%

80% / 20%

viridian

indanthrene blue

Winsor emerald

manganese blue hue

cadmium green pale

phthalo turquoise

cobalt turquoise

cadmium scarlet

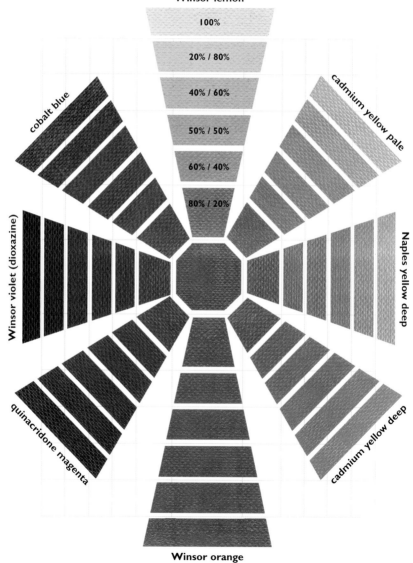

Winsor lemon

100%

20% / 80%

40% / 60%

50% / 50%

60% / 40%

80% / 20%

cadmium yellow pale

cobalt blue

Naples yellow deep

Winsor violet (dioxazine)

cadmium yellow deep

quinacridone magenta

Winsor orange

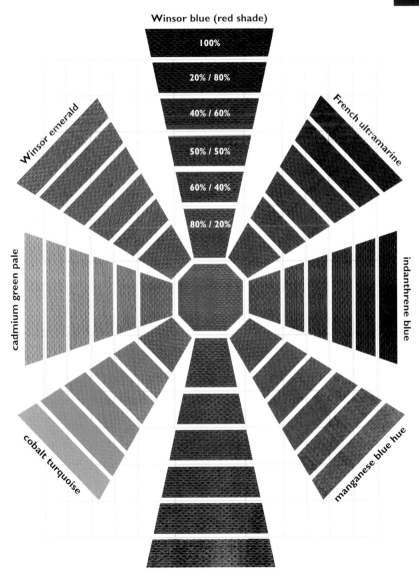

Winsor blue (red shade)

100%

20% / 80%

40% / 60%

50% / 50%

60% / 40%

80% / 20%

French ultramarine

Winsor emerald

cadmium green pale

indanthrene blue

cobalt turquoise

manganese blue hue

phthalo turquoise

Winsor red deep

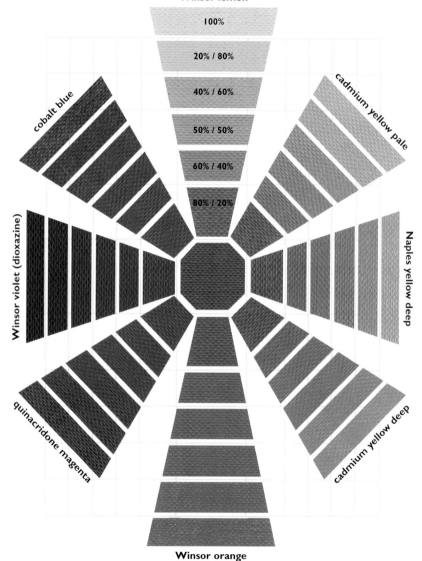

Winsor lemon

100%

20% / 80%

40% / 60%

50% / 50%

60% / 40%

80% / 20%

cobalt blue

cadmium yellow pale

Winsor violet (dioxazine)

Naples yellow deep

quinacridone magenta

cadmium yellow deep

Winsor orange

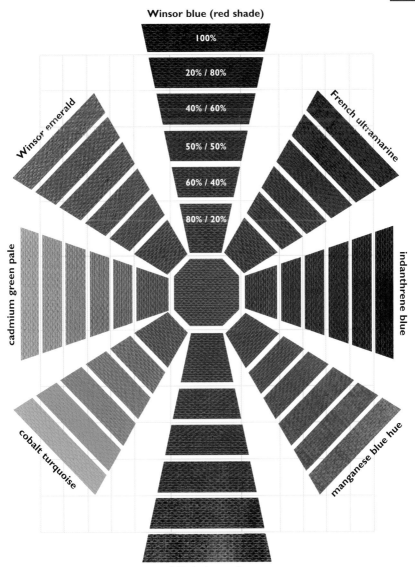

Winsor blue (red shade)

100%

20% / 80%

40% / 60%

50% / 50%

60% / 40%

80% / 20%

Winsor emerald

French ultramarine

cadmium green pale

indanthrene blue

cobalt turquoise

manganese blue hue

phthalo turquoise

permanent rose

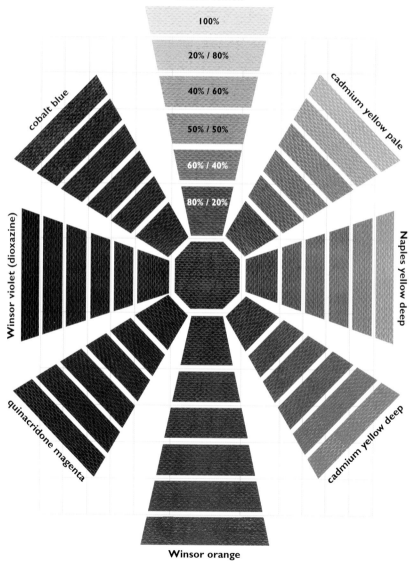

Winsor lemon

100%

20% / 80%

40% / 60%

50% / 50%

60% / 40%

80% / 20%

cadmium yellow pale

cobalt blue

Naples yellow deep

Winsor violet (dioxazine)

cadmium yellow deep

quinacridone magenta

Winsor orange

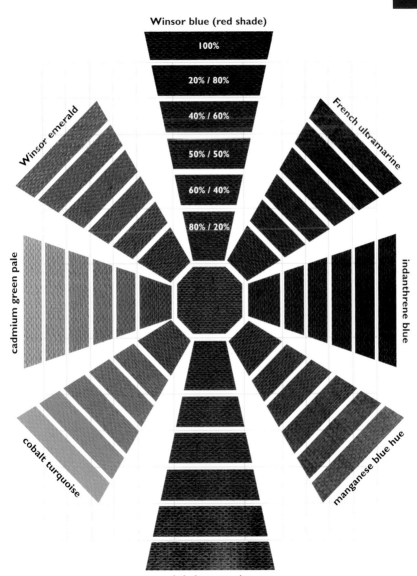

Winsor blue (red shade)

100%

20% / 80%

40% / 60%

50% / 50%

60% / 40%

80% / 20%

Winsor emerald

French ultramarine

cadmium green pale

indanthrene blue

cobalt turquoise

manganese blue hue

phthalo turquoise

permanent alizarin crimson

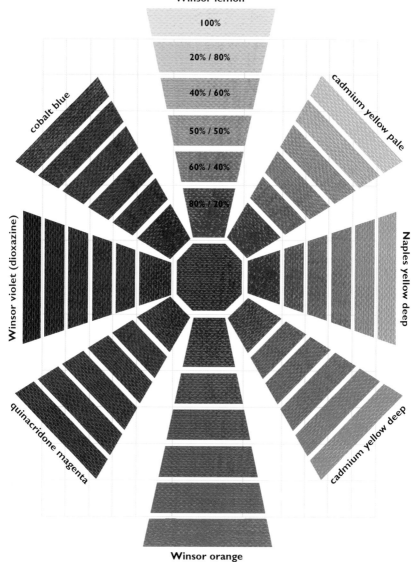

Winsor lemon

100%

20% / 80%

40% / 60%

50% / 50%

60% / 40%

80% / 20%

cobalt blue

cadmium yellow pale

Winsor violet (dioxazine)

Naples yellow deep

quinacridone magenta

cadmium yellow deep

Winsor orange

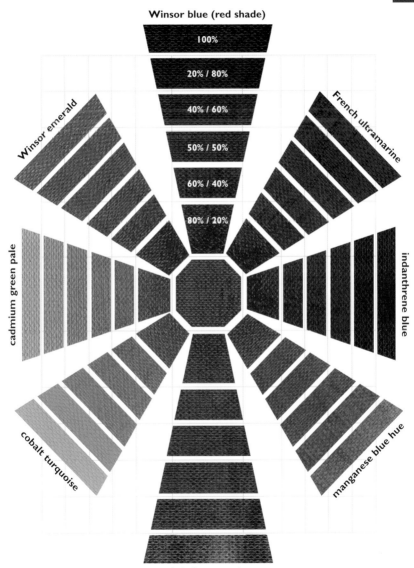

Winsor blue (red shade)

100%

20% / 80%

40% / 60%

50% / 50%

60% / 40%

80% / 20%

Winsor emerald

French ultramarine

cadmium green pale

indanthrene blue

cobalt turquoise

manganese blue hue

phthalo turquoise

quinacridone magenta

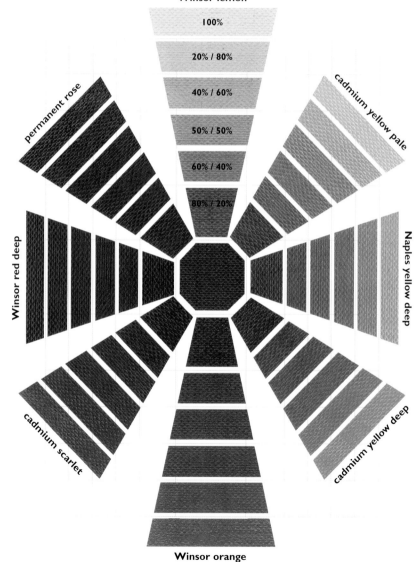

Winsor lemon

permanent rose

cadmium yellow pale

Winsor red deep

Naples yellow deep

100%
20% / 80%
40% / 60%
50% / 50%
60% / 40%
80% / 20%

cadmium scarlet

cadmium yellow deep

Winsor orange

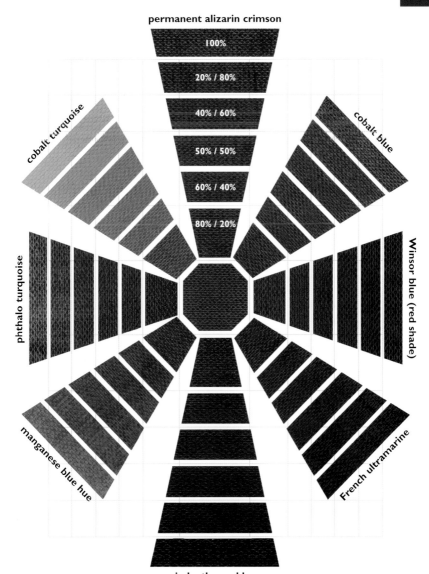

permanent alizarin crimson

100%

20% / 80%

40% / 60%

50% / 50%

60% / 40%

80% / 20%

cobalt turquoise

cobalt blue

phthalo turquoise

Winsor blue (red shade)

manganese blue hue

French ultramarine

indanthrene blue

Winsor violet (dioxazine)

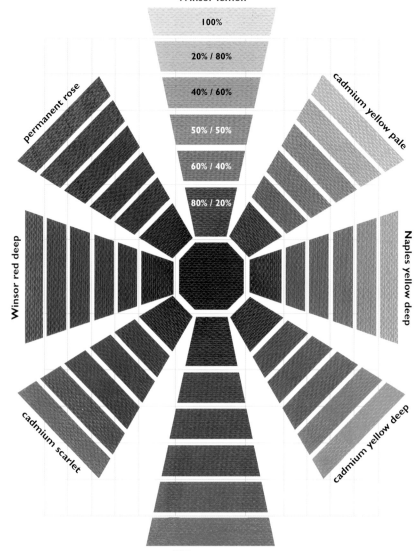

Winsor lemon

100%

20% / 80%

40% / 60%

50% / 50%

60% / 40%

80% / 20%

cadmium yellow pale

Naples yellow deep

permanent rose

Winsor red deep

cadmium scarlet

cadmium yellow deep

Winsor orange

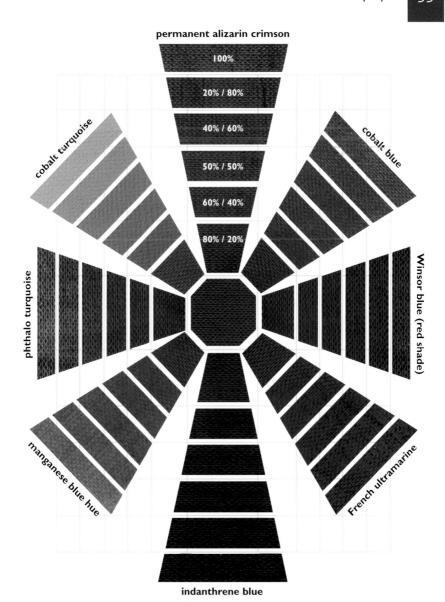

permanent alizarin crimson

100%

20% / 80%

40% / 60%

50% / 50%

60% / 40%

80% / 20%

cobalt turquoise

cobalt blue

phthalo turquoise

Winsor blue (red shade)

manganese blue hue

French ultramarine

indanthrene blue

cobalt blue

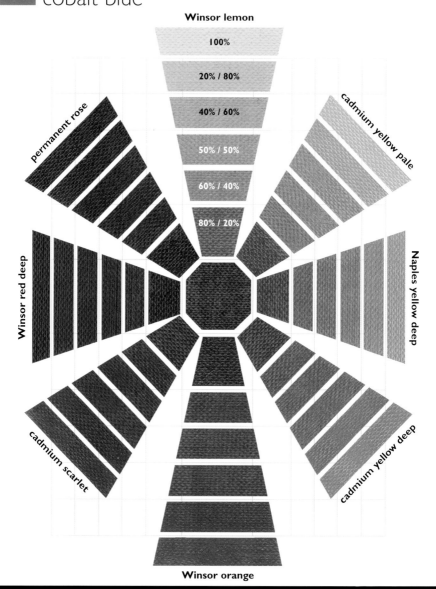

Winsor lemon

100%

20% / 80%

40% / 60%

50% / 50%

60% / 40%

80% / 20%

permanent rose

cadmium yellow pale

Winsor red deep

Naples yellow deep

cadmium scarlet

cadmium yellow deep

Winsor orange

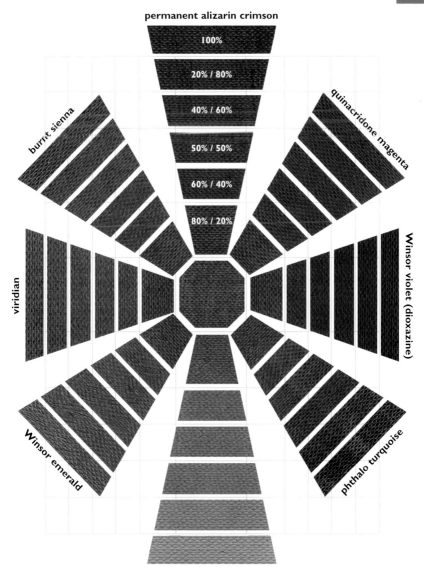

permanent alizarin crimson

100%

20% / 80%

40% / 60%

50% / 50%

60% / 40%

80% / 20%

burnt sienna

quinacridone magenta

viridian

Winsor violet (dioxazine)

Winsor emerald

phthalo turquoise

cadmium green pale

Winsor blue (red shade)

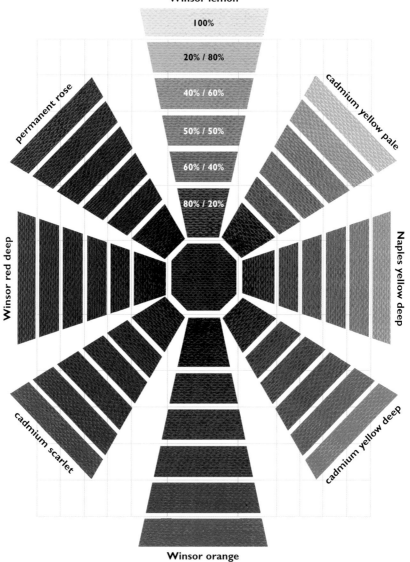

Winsor lemon

100%

20% / 80%

40% / 60%

50% / 50%

60% / 40%

80% / 20%

permanent rose

cadmium yellow pale

Winsor red deep

Naples yellow deep

cadmium scarlet

cadmium yellow deep

Winsor orange

◄◄ ◄◄ ◄◄ more purple

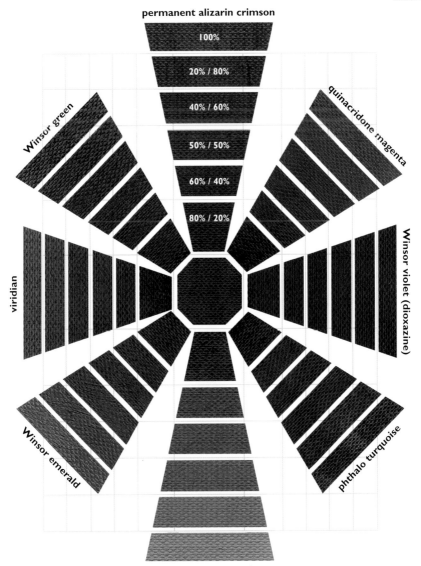

permanent alizarin crimson

100%

20% / 80%

40% / 60%

50% / 50%

60% / 40%

80% / 20%

Winsor green

quinacridone magenta

viridian

Winsor violet (dioxazine)

Winsor emerald

phthalo turquoise

cadmium green pale

French ultramarine

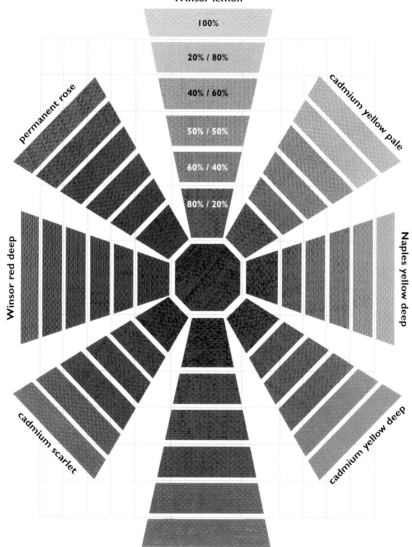

Winsor lemon

100%

20% / 80%

40% / 60%

50% / 50%

60% / 40%

80% / 20%

permanent rose

cadmium yellow pale

Winsor red deep

Naples yellow deep

cadmium scarlet

cadmium yellow deep

Winsor orange

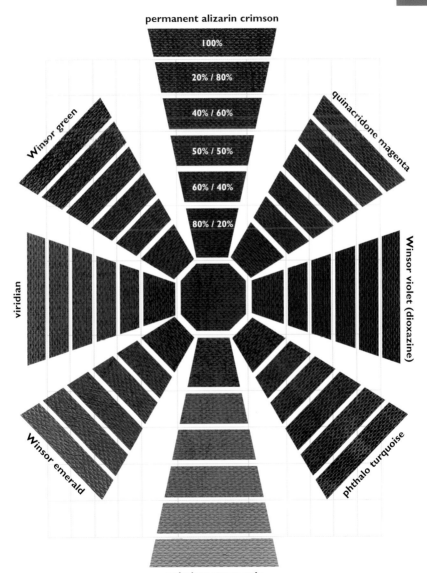

permanent alizarin crimson

100%

20% / 80%

40% / 60%

50% / 50%

60% / 40%

80% / 20%

Winsor green

quinacridone magenta

viridian

Winsor violet (dioxazine)

Winsor emerald

phthalo turquoise

cadmium green pale

indanthrene blue

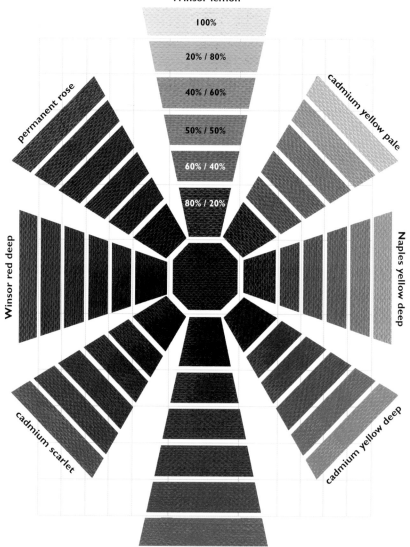

Winsor lemon

100%

20% / 80%

40% / 60%

50% / 50%

60% / 40%

80% / 20%

permanent rose

cadmium yellow pale

Winsor red deep

Naples yellow deep

cadmium scarlet

cadmium yellow deep

Winsor orange

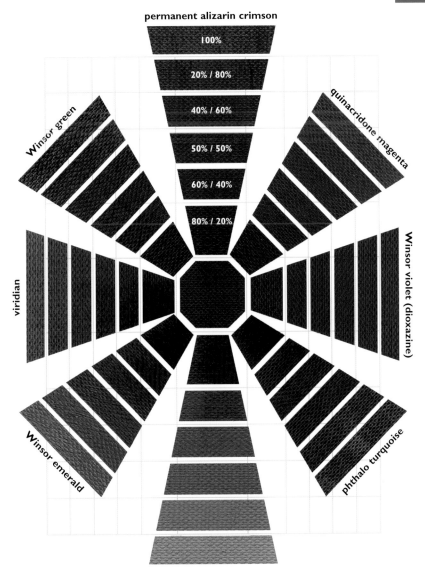

permanent alizarin crimson

100%

20% / 80%

40% / 60%

50% / 50%

60% / 40%

80% / 20%

Winsor green

quinacridone magenta

Winsor violet (dioxazine)

viridian

Winsor emerald

phthalo turquoise

cadmium green pale

manganese blue hue

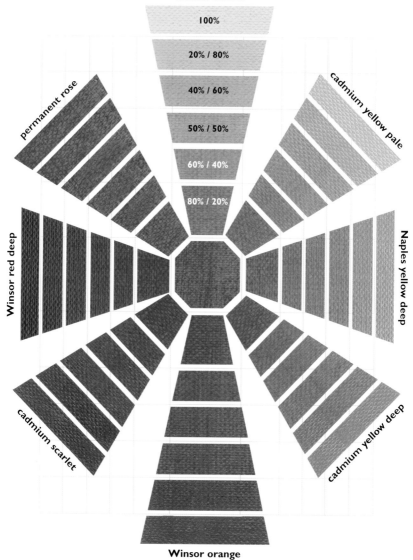

Winsor lemon

100%

20% / 80%

40% / 60%

50% / 50%

60% / 40%

80% / 20%

permanent rose

cadmium yellow pale

Winsor red deep

Naples yellow deep

cadmium scarlet

cadmium yellow deep

Winsor orange

permanent alizarin crimson

100%

20% / 80%

40% / 60%

50% / 50%

60% / 40%

80% / 20%

Winsor green

quinacridone magenta

viridian

Winsor violet (dioxazine)

Winsor emerald

phthalo turquoise

cadmium green pale

phthalo turquoise

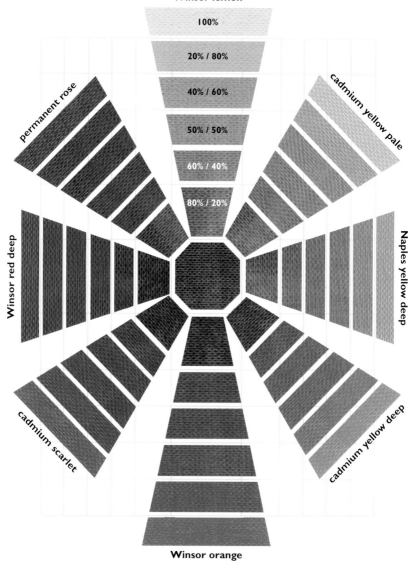

Winsor lemon

100%

20% / 80%

40% / 60%

50% / 50%

60% / 40%

80% / 20%

cadmium yellow pale

permanent rose

Winsor red deep

Naples yellow deep

cadmium scarlet

cadmium yellow deep

Winsor orange

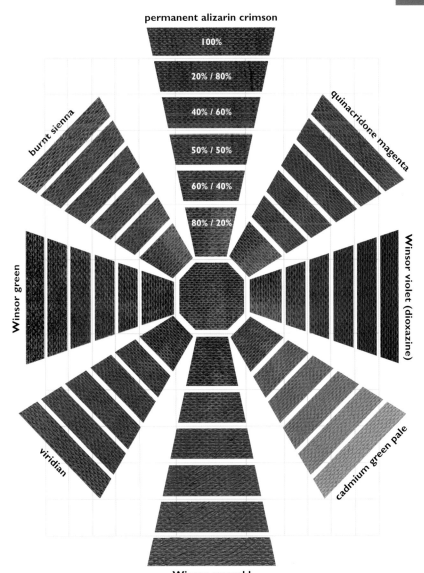

permanent alizarin crimson

100%

20% / 80%

40% / 60%

50% / 50%

60% / 40%

80% / 20%

burnt sienna

quinacridone magenta

Winsor green

Winsor violet (dioxazine)

viridian

cadmium green pale

Winsor emerald

cobalt turquoise

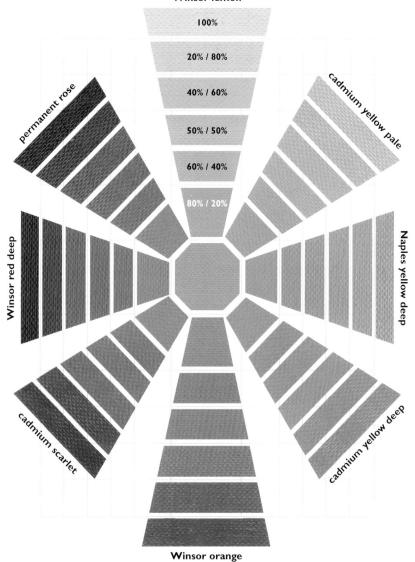

Winsor lemon

100%

20% / 80%

40% / 60%

50% / 50%

60% / 40%

80% / 20%

permanent rose

cadmium yellow pale

Winsor red deep

Naples yellow deep

cadmium scarlet

cadmium yellow deep

Winsor orange

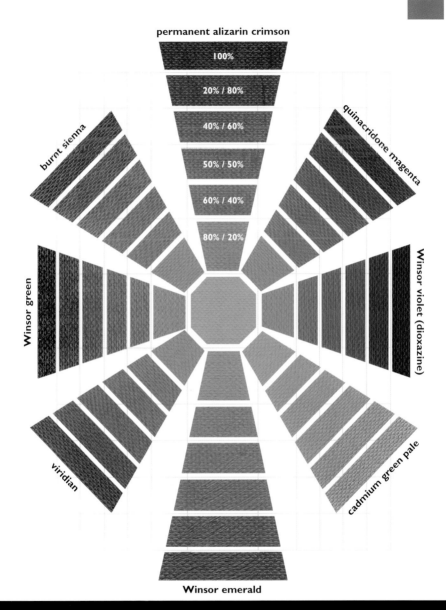

permanent alizarin crimson

100%

20% / 80%

40% / 60%

50% / 50%

60% / 40%

80% / 20%

burnt sienna

quinacridone magenta

Winsor green

Winsor violet (dioxazine)

viridian

cadmium green pale

Winsor emerald

cadmium green pale

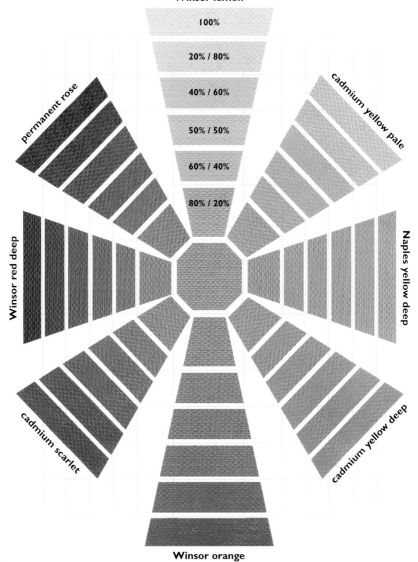

Winsor lemon

100%

20% / 80%

40% / 60%

50% / 50%

60% / 40%

80% / 20%

permanent rose

cadmium yellow pale

Winsor red deep

Naples yellow deep

cadmium scarlet

cadmium yellow deep

Winsor orange

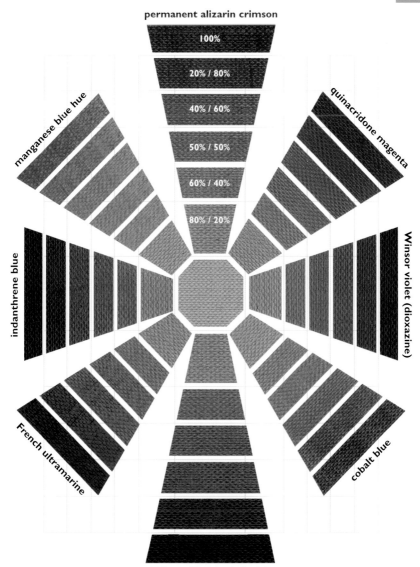

permanent alizarin crimson

100%

20% / 80%

40% / 60%

50% / 50%

60% / 40%

80% / 20%

manganese blue hue

quinacridone magenta

indanthrene blue

Winsor violet (dioxazine)

French ultramarine

cobalt blue

Winsor blue (red shade)

Winsor emerald

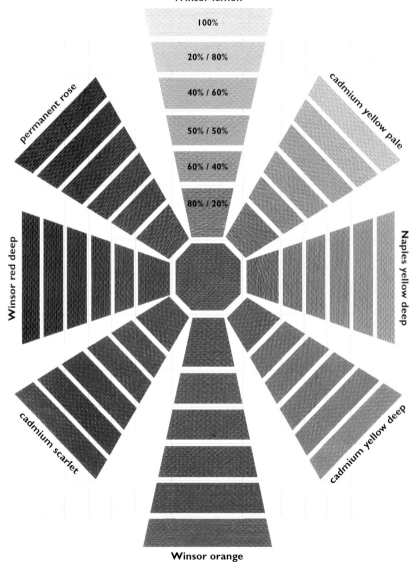

Winsor lemon

100%

20% / 80%

40% / 60%

50% / 50%

60% / 40%

80% / 20%

permanent rose

cadmium yellow pale

Winsor red deep

Naples yellow deep

cadmium scarlet

cadmium yellow deep

Winsor orange

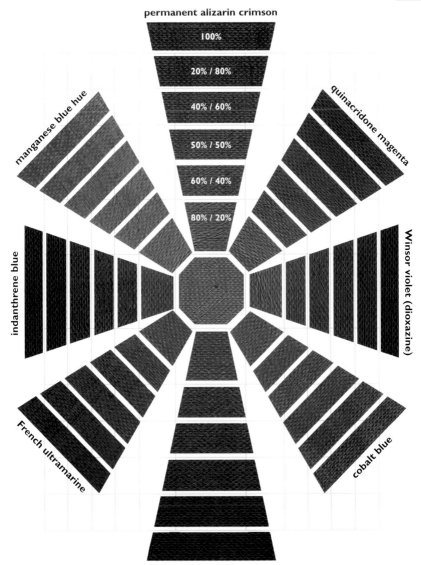

permanent alizarin crimson

100%

20% / 80%

40% / 60%

50% / 50%

60% / 40%

80% / 20%

manganese blue hue

quinacridone magenta

indanthrene blue

Winsor violet (dioxazine)

French ultramarine

cobalt blue

Winsor blue (red shade)

viridian

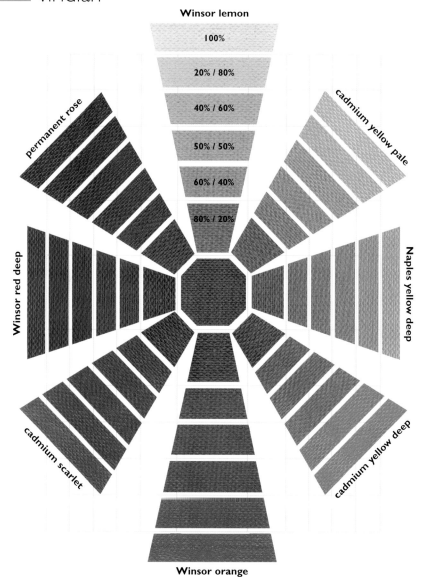

Winsor lemon

100%

20% / 80%

40% / 60%

50% / 50%

60% / 40%

80% / 20%

permanent rose

cadmium yellow pale

Winsor red deep

Naples yellow deep

cadmium scarlet

cadmium yellow deep

Winsor orange

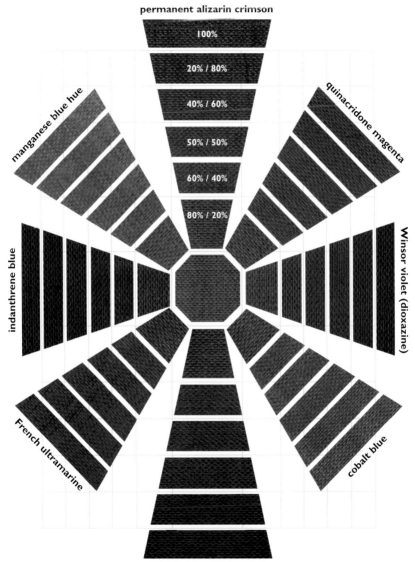

permanent alizarin crimson

100%

20% / 80%

40% / 60%

50% / 50%

60% / 40%

80% / 20%

manganese blue hue

quinacridone magenta

indanthrene blue

Winsor violet (dioxazine)

French ultramarine

cobalt blue

Winsor blue (red shade)

Winsor green

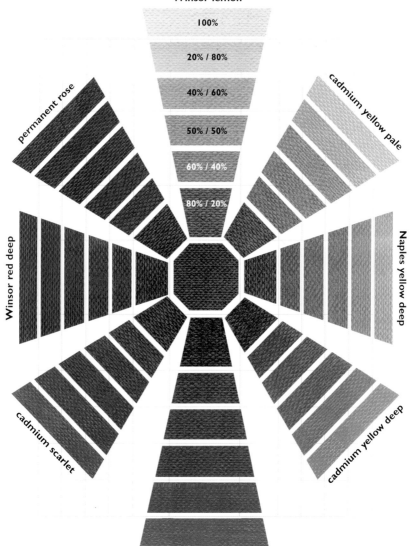

Winsor lemon

100%

20% / 80%

40% / 60%

50% / 50%

60% / 40%

80% / 20%

cadmium yellow pale

permanent rose

Winsor red deep

Naples yellow deep

cadmium scarlet

cadmium yellow deep

Winsor orange

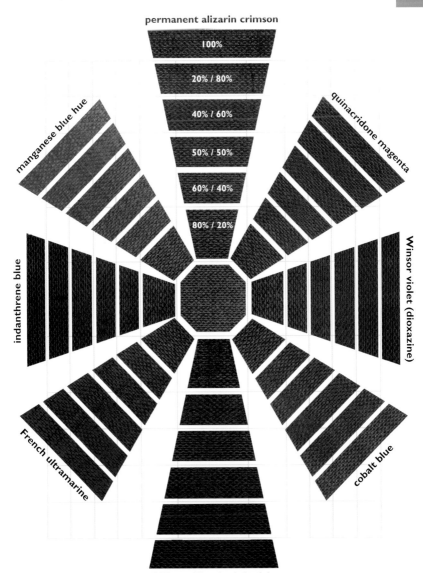

permanent alizarin crimson

100%

20% / 80%

40% / 60%

50% / 50%

60% / 40%

80% / 20%

manganese blue hue

quinacridone magenta

indanthrene blue

Winsor violet (dioxazine)

French ultramarine

cobalt blue

Winsor blue (red shade)

burnt sienna

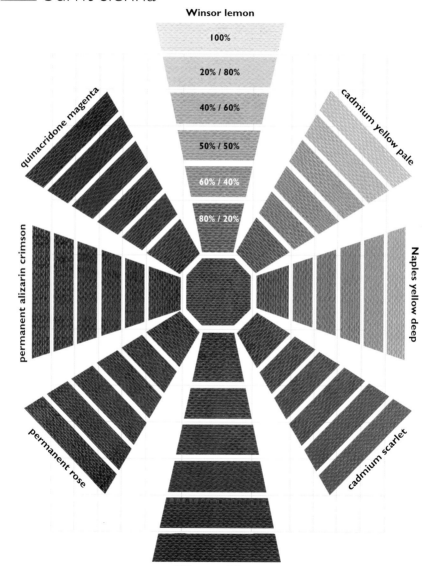

Winsor lemon

100%

20% / 80%

40% / 60%

50% / 50%

60% / 40%

80% / 20%

quinacridone magenta

cadmium yellow pale

permanent alizarin crimson

Naples yellow deep

permanent rose

cadmium scarlet

Winsor red deep

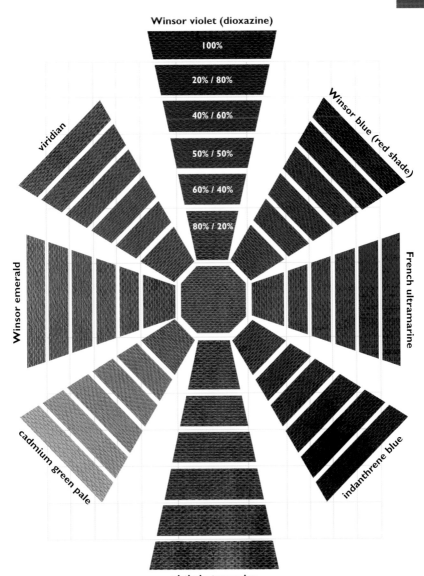

Winsor violet (dioxazine)

100%

20% / 80%

40% / 60%

50% / 50%

60% / 40%

80% / 20%

viridian

Winsor blue (red shade)

Winsor emerald

French ultramarine

cadmium green pale

indanthrene blue

phthalo turquoise

light red

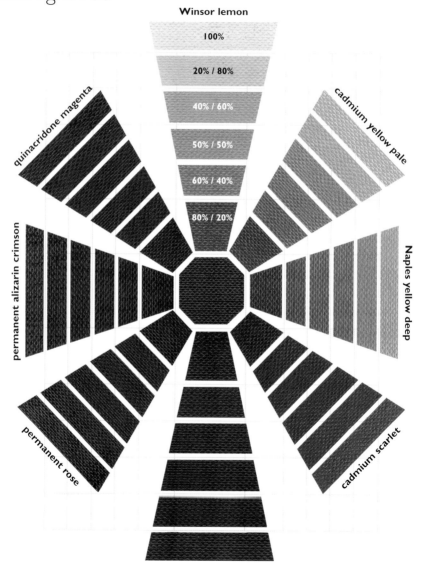

Winsor lemon

100%

20% / 80%

40% / 60%

50% / 50%

60% / 40%

80% / 20%

quinacridone magenta

cadmium yellow pale

permanent alizarin crimson

Naples yellow deep

permanent rose

cadmium scarlet

Winsor red deep

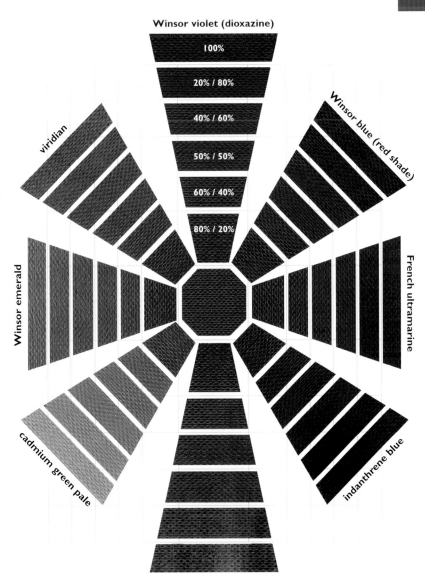

Winsor violet (dioxazine)

100%

20% / 80%

40% / 60%

50% / 50%

60% / 40%

80% / 20%

Winsor blue (red shade)

French ultramarine

indanthrene blue

phthalo turquoise

cadmium green pale

Winsor emerald

viridian

raw umber

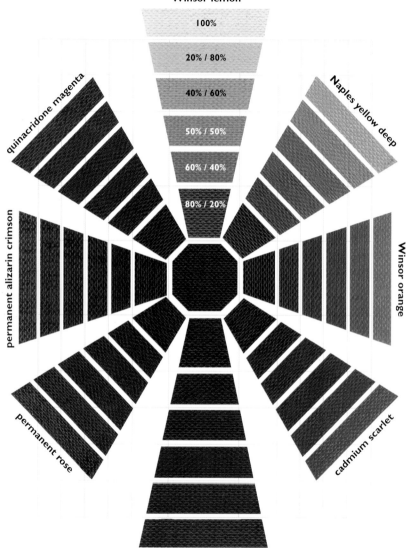

Winsor lemon

100%

20% / 80%

40% / 60%

50% / 50%

60% / 40%

80% / 20%

quinacridone magenta

Naples yellow deep

permanent alizarin crimson

Winsor orange

permanent rose

cadmium scarlet

Winsor red deep

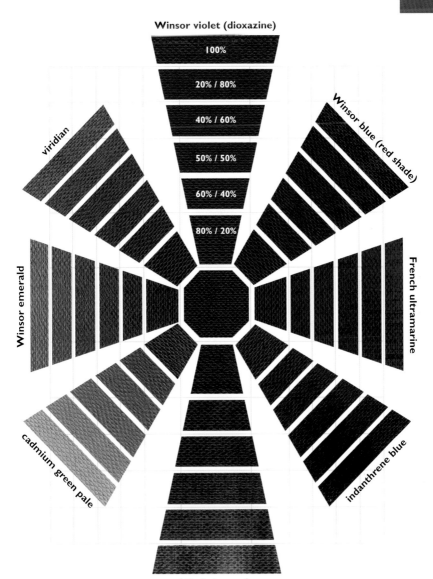

Winsor violet (dioxazine)

100%

20% / 80%

40% / 60%

50% / 50%

60% / 40%

80% / 20%

Winsor blue (red shade)

viridian

French ultramarine

Winsor emerald

cadmium green pale

indanthrene blue

phthalo turquoise

index

acknowledgements

Photographs on pp. 6–7, 10, 11 © Winsor & Newton™